T0131916

AuthorHouse™ UK
1663 Liberty Drive
Bloomington, IN 47403 USA
www.authorhouse.co.uk
Phone: 0800 047 8203 (Domestic TFN)
+44 1908 723714 (International)

Published by AuthorHouse 05/31/2019

ISBN: 978-1-7283-8297-5 (sc)
978-1-7283-8296-8 (e)

Print information available on the last page.

Any people depicted in stock imagery provided by Getty Images are models,
and such images are being used for illustrative purposes only.
Certain stock imagery © Getty Images.

This book is printed on acid-free paper.

authorHOUSE®

The Flea Who Found His Chi

Written and illustrated by

Claire Burch

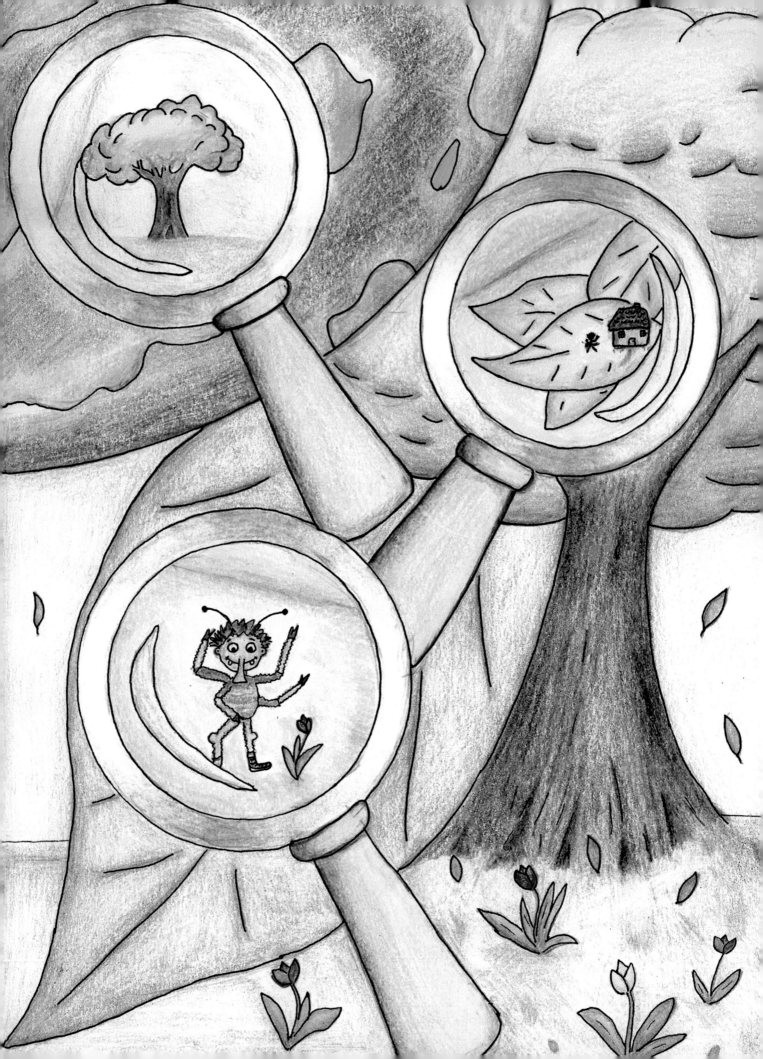

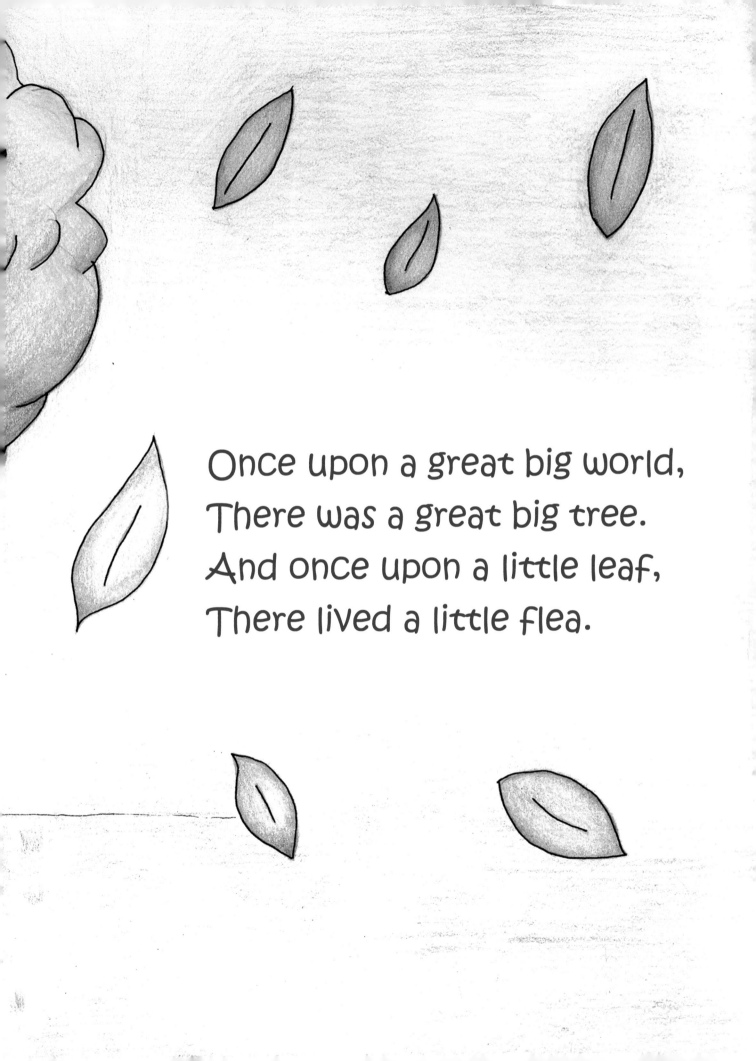

Once upon a great big world,
There was a great big tree.
And once upon a little leaf,
There lived a little flea.

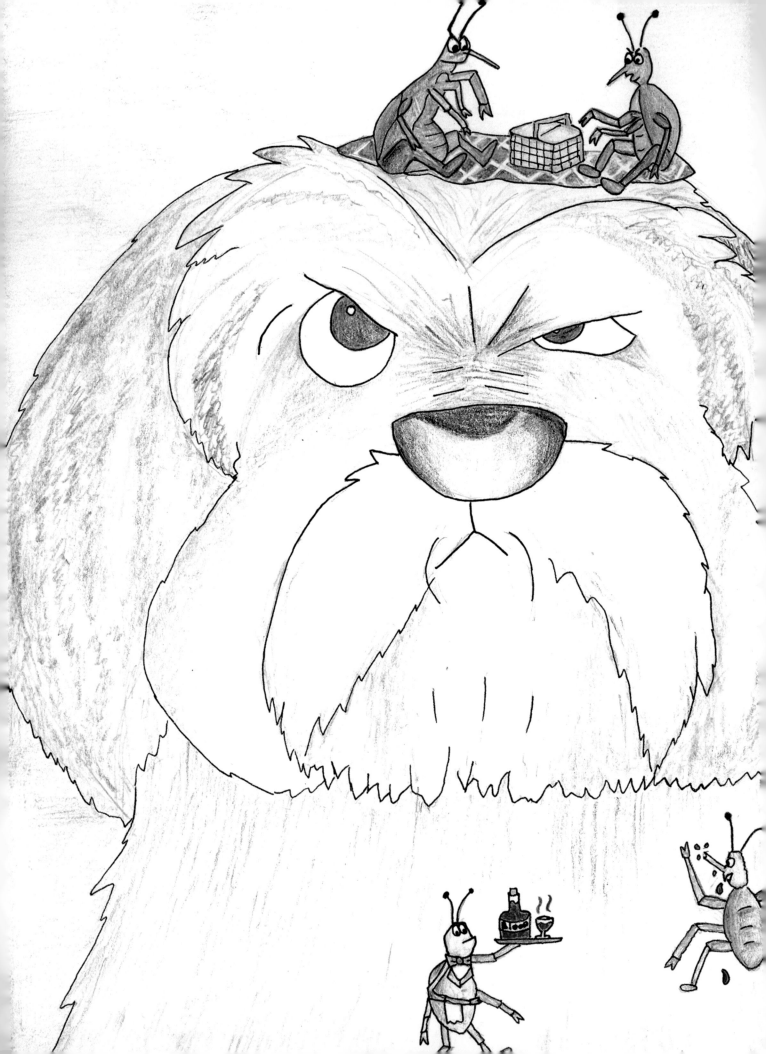

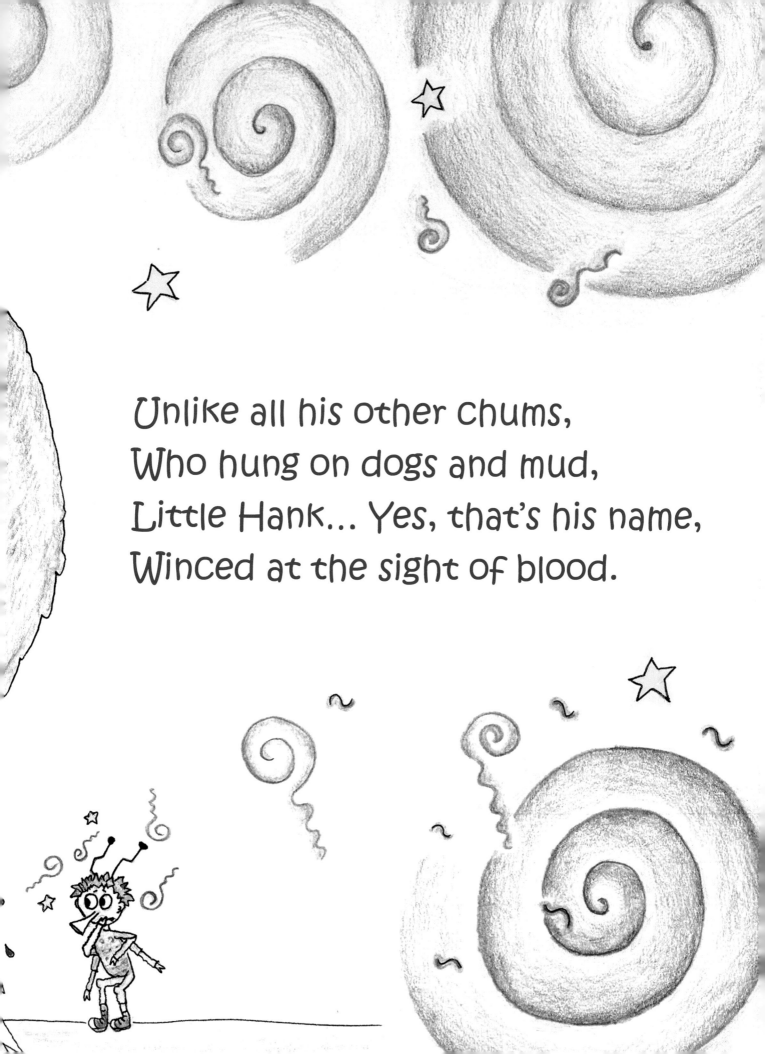

Unlike all his other chums,
Who hung on dogs and mud,
Little Hank... Yes, that's his name,
Winced at the sight of blood.

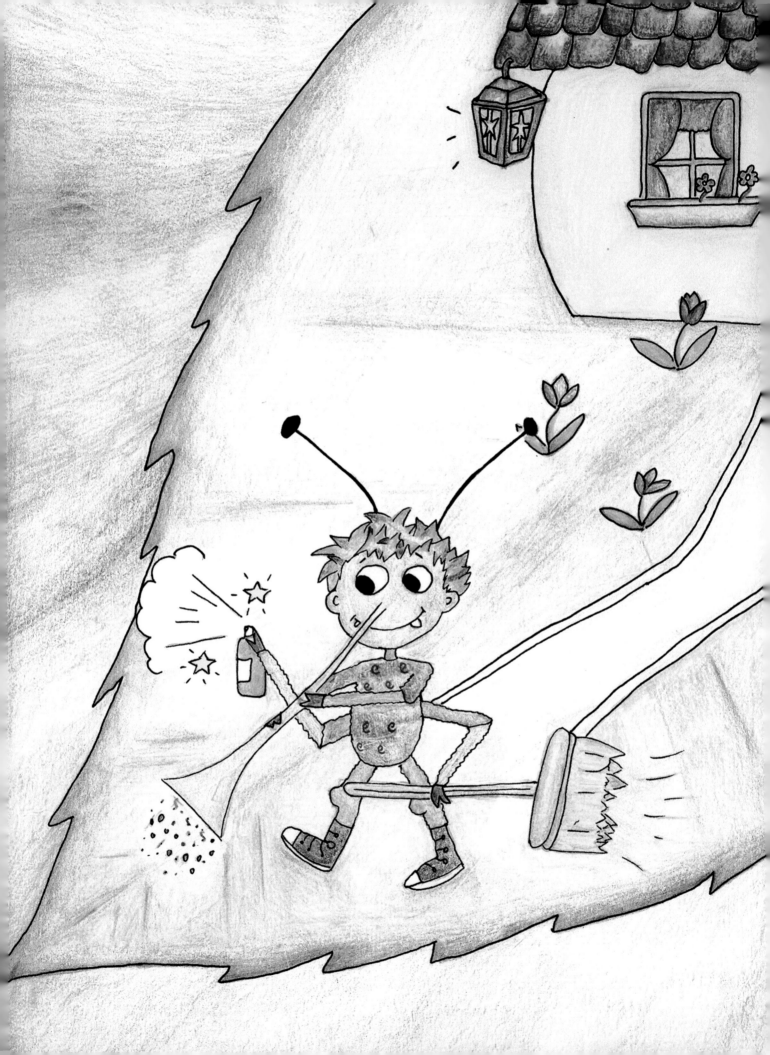

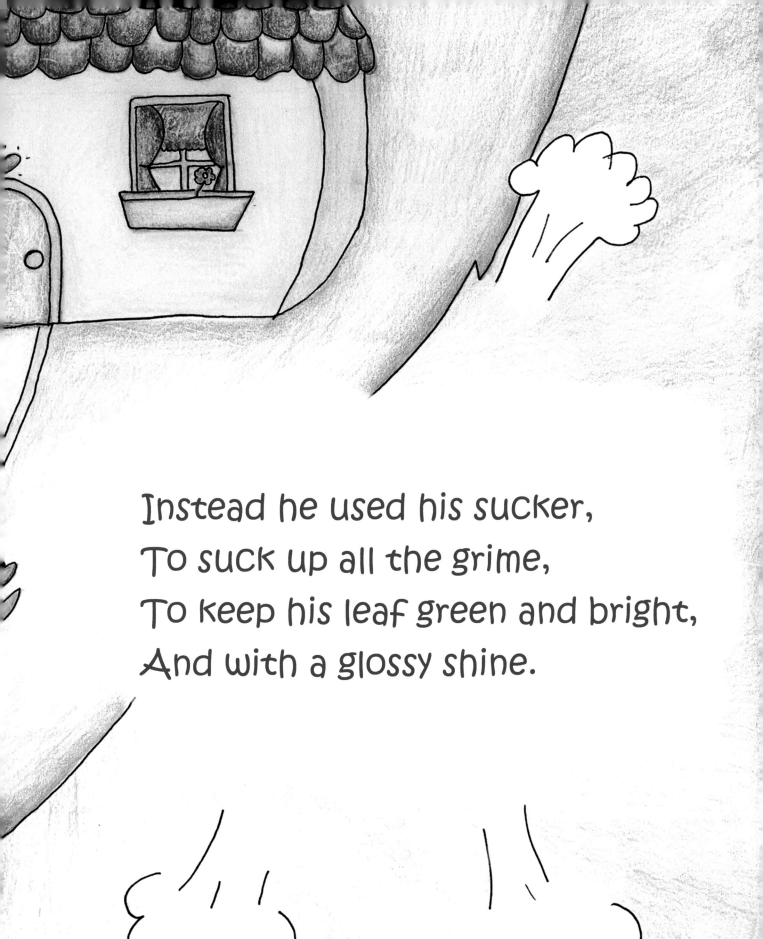

Instead he used his sucker,
To suck up all the grime,
To keep his leaf green and bright,
And with a glossy shine.

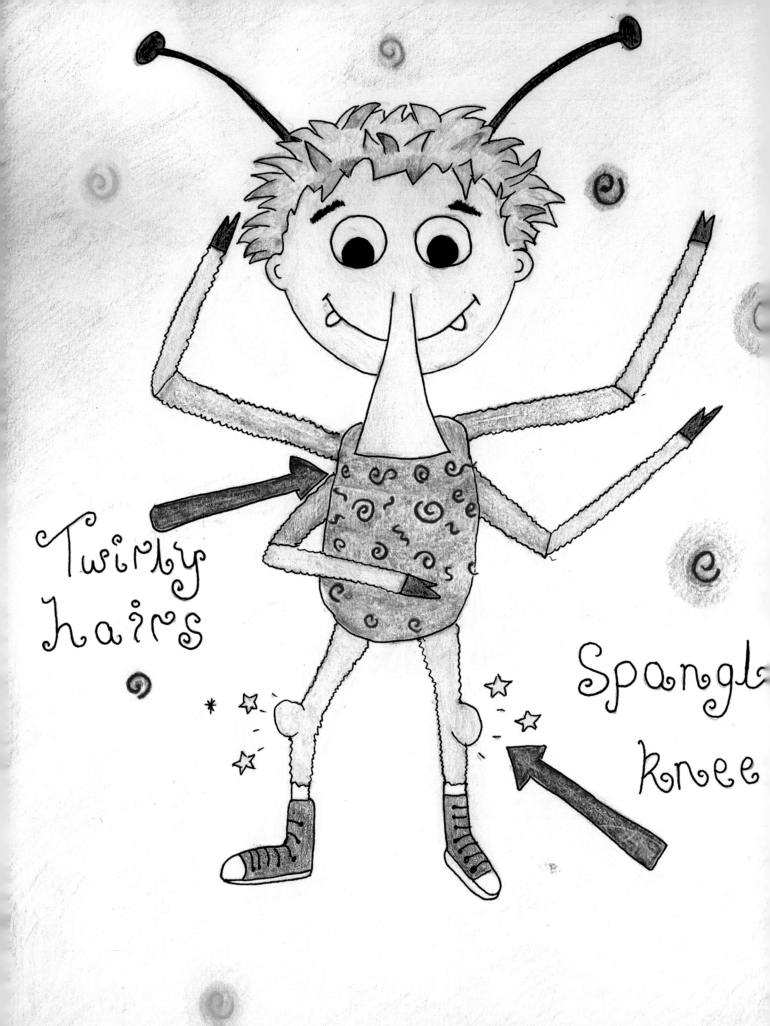

Now Little Hank was pretty swell,
As you may have guessed,
He had some springy, spangly knees,
And twirly hairs upon his chest.

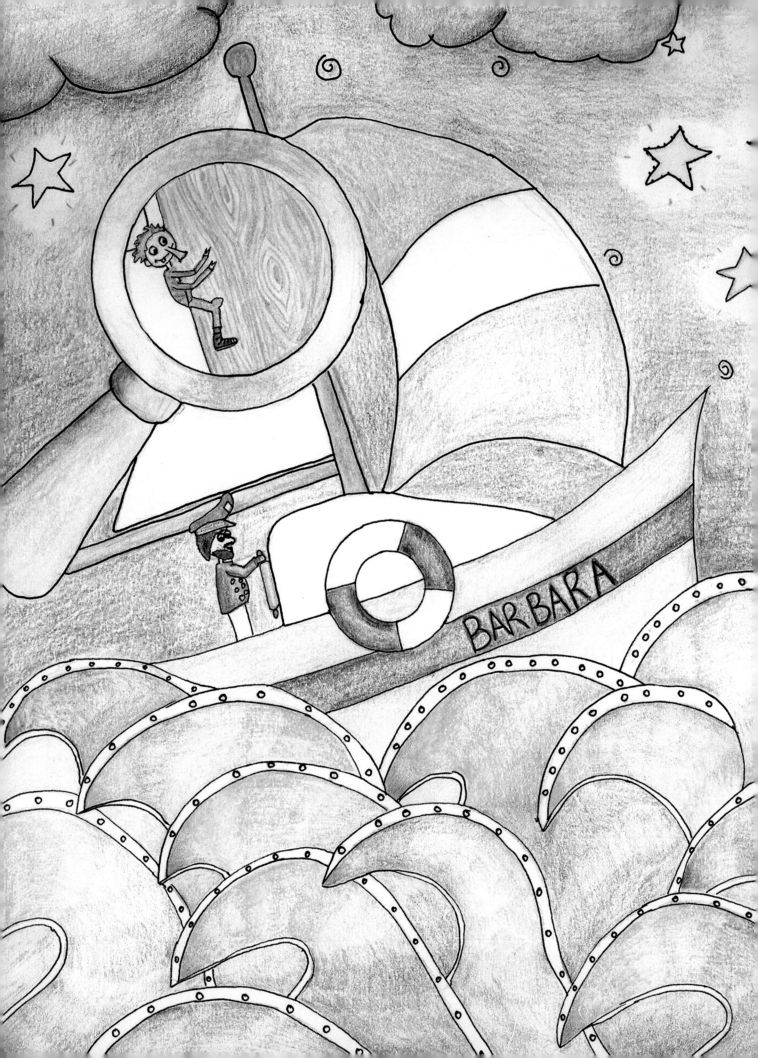

He liked to whizz across the land,
And sail over the sea,
Clinging on to something tight,
Was where our Hank would be.

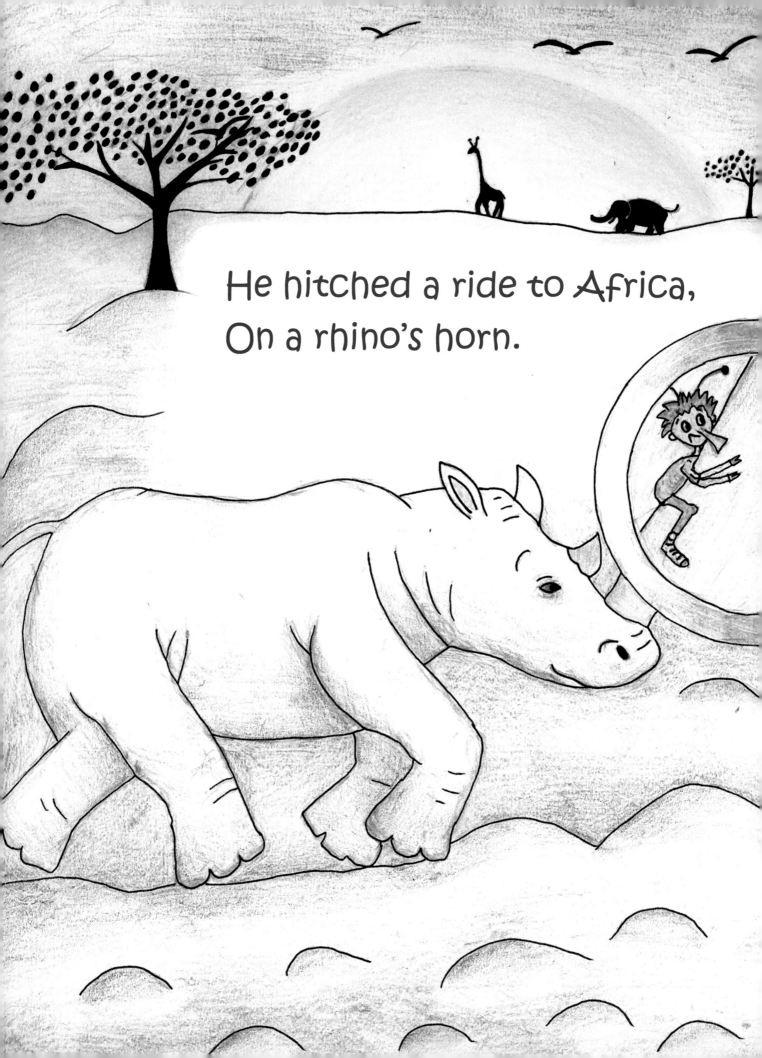

He hitched a ride to Africa,
On a rhino's horn.

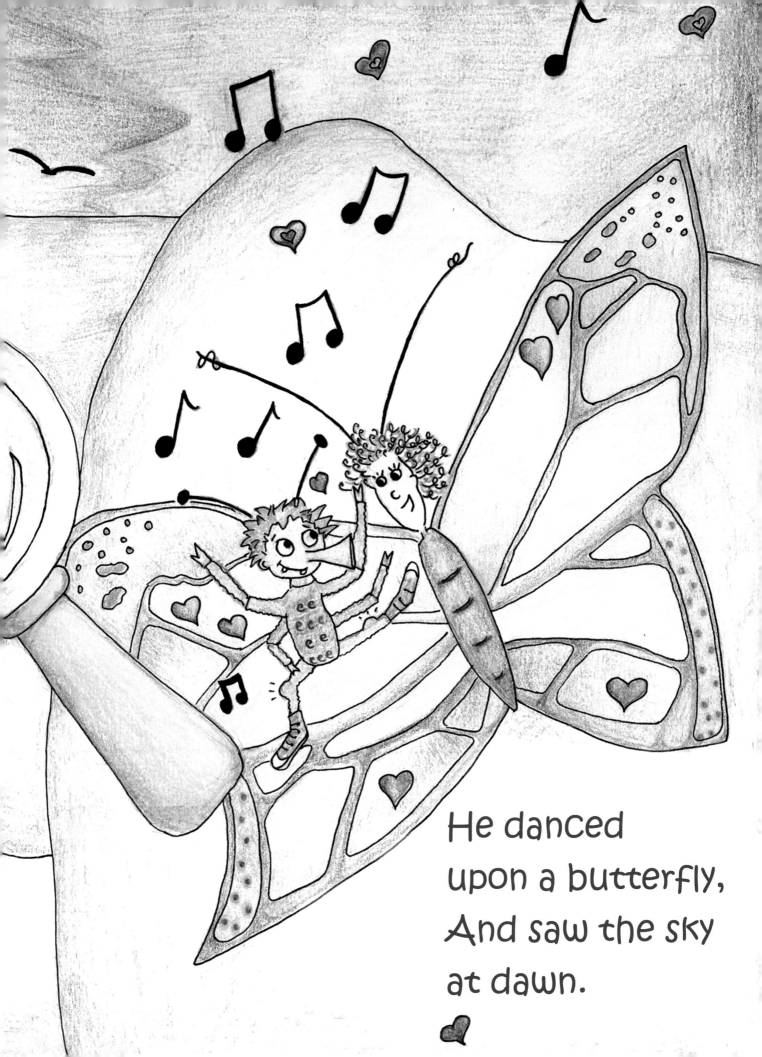

He danced
upon a butterfly,
And saw the sky
at dawn.

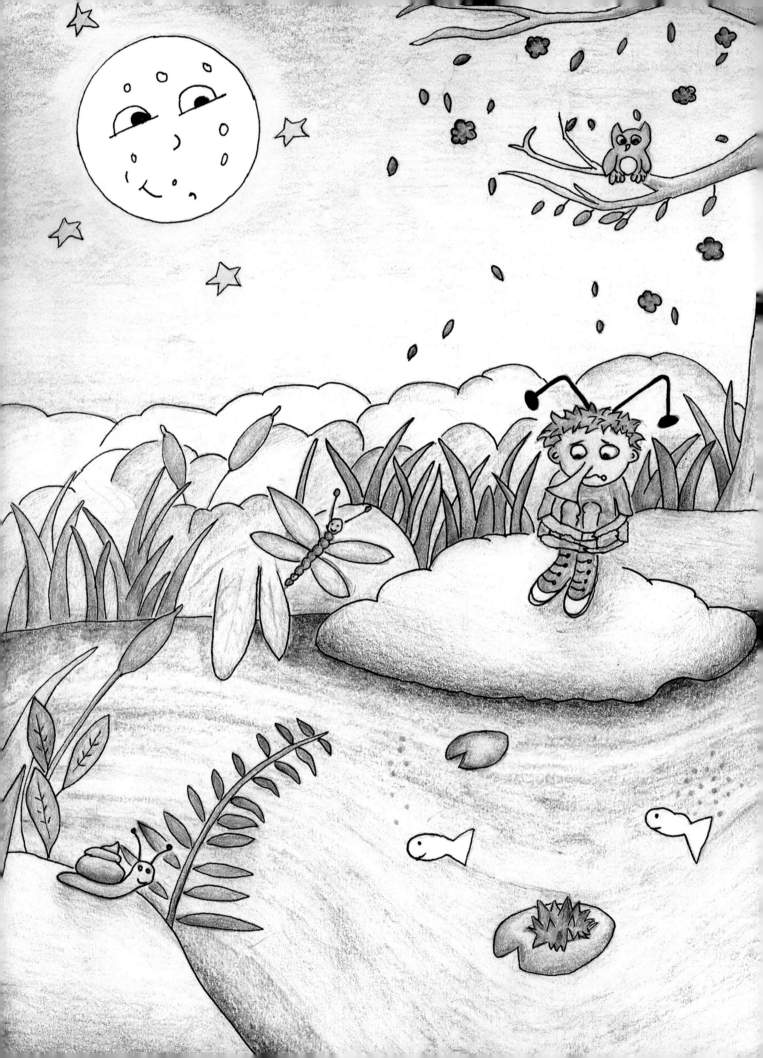

But little Hank was not fulfilled,
Always hanging on.
Always on another's path,
Which he did not belong.

He longed for
his own journey,
Where he could
just be free.

Whilst dreaming of adventure,
Stood there wisely was...

'THE BEE!'

"To discover one's own path,
Strength within must now be seen."

"My dear chap," Hank replied,
"What the bally ho do you mean?"

Now patience is a virtue,
And that Bee tried to seize,

"For pities sake, you silly fool,
Just look down at your knees!"

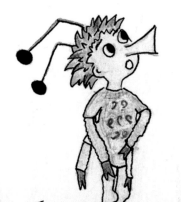

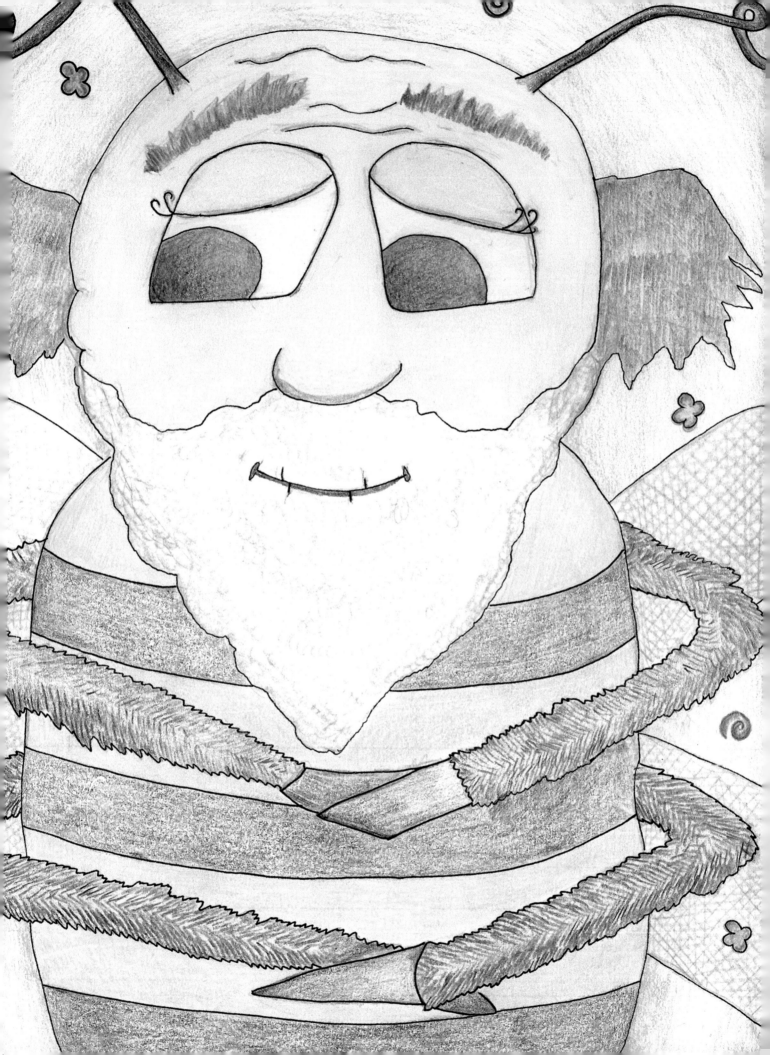

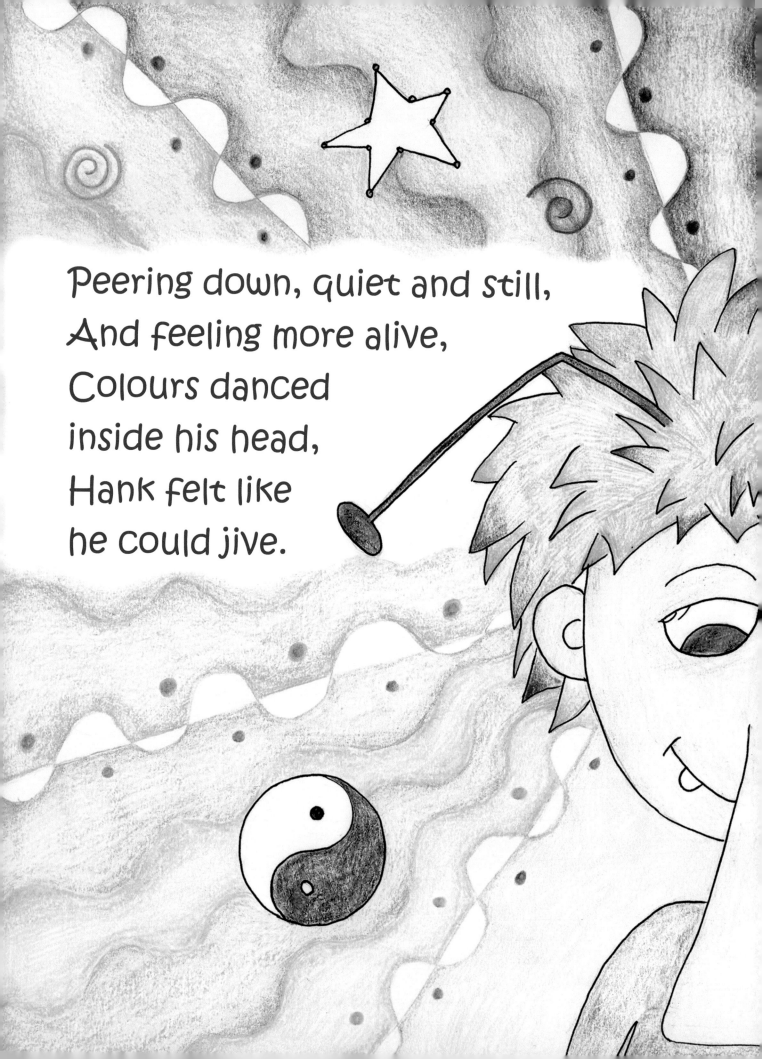

Peering down, quiet and still,
And feeling more alive,
Colours danced
inside his head,
Hank felt like
he could jive.

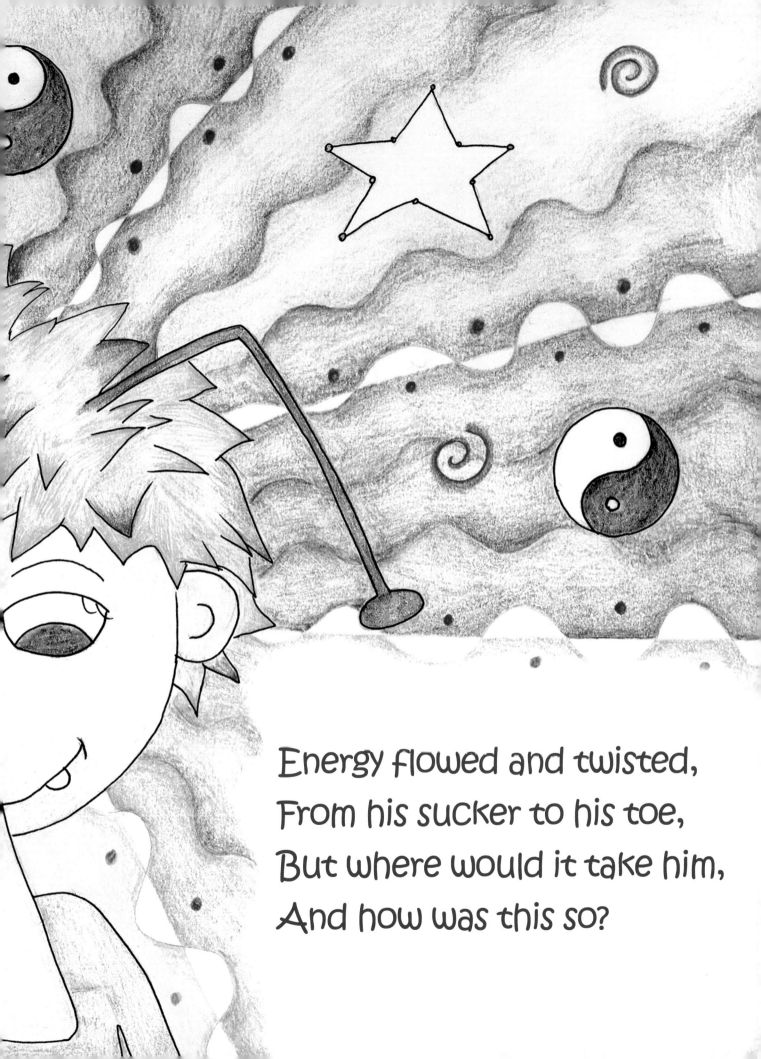

Energy flowed and twisted,
From his sucker to his toe,
But where would it take him,
And how was this so?

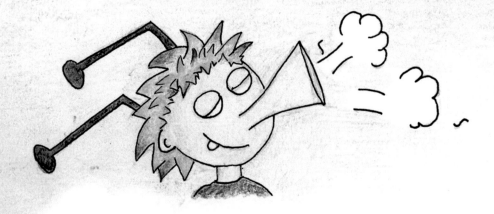

With one deep breath,
He clicked his heels,
And wibbled his furry knees,

WHOOSH !

Up he flew, into the blue,
With marvel and with glee!

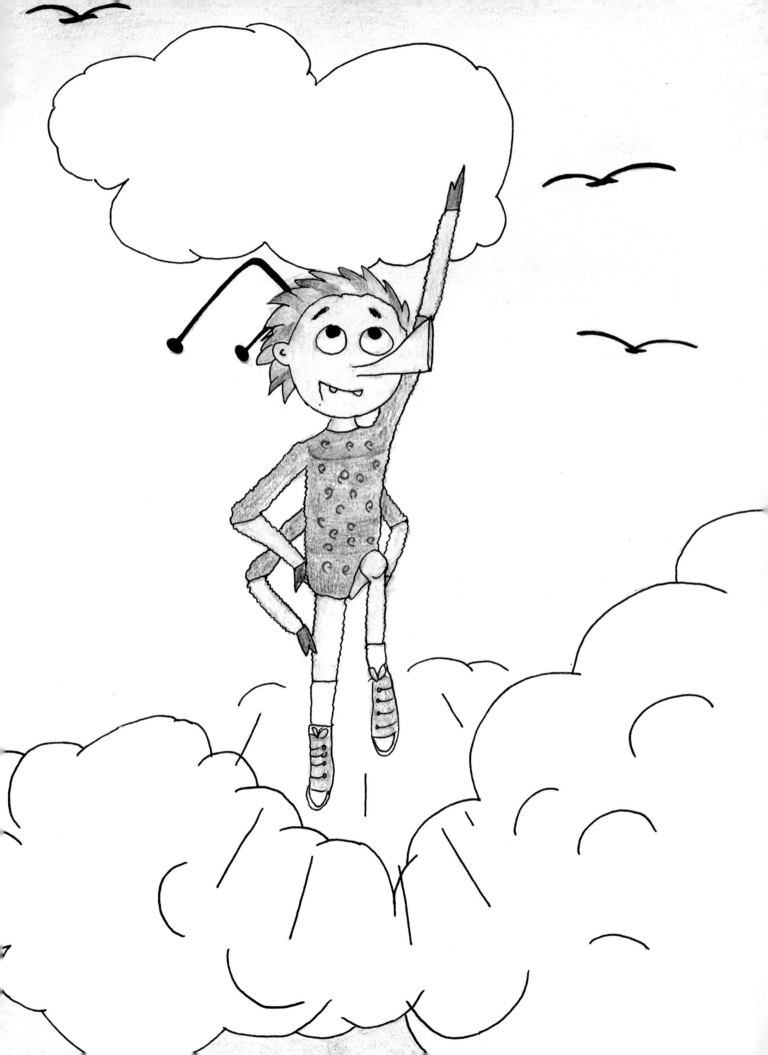

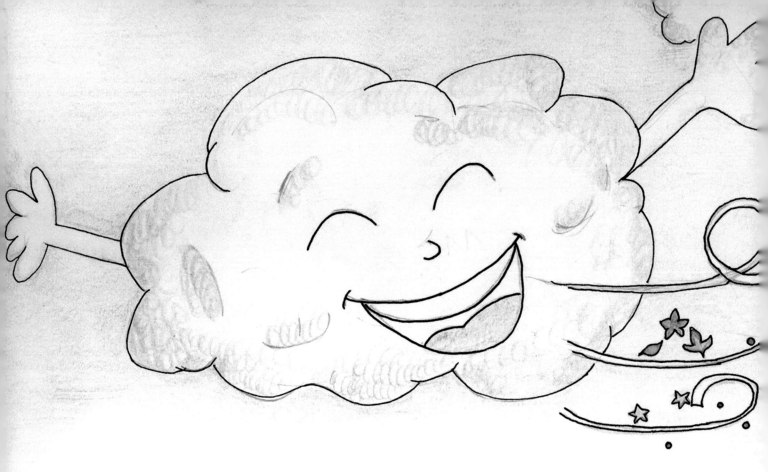

Zooming through the trees he went,
And through the clouds he soared,

The birds, they looked on gasping,
And the wind just laughed and roared.

He climbed and climbed way up high,
Who ever knew a flea could fly?

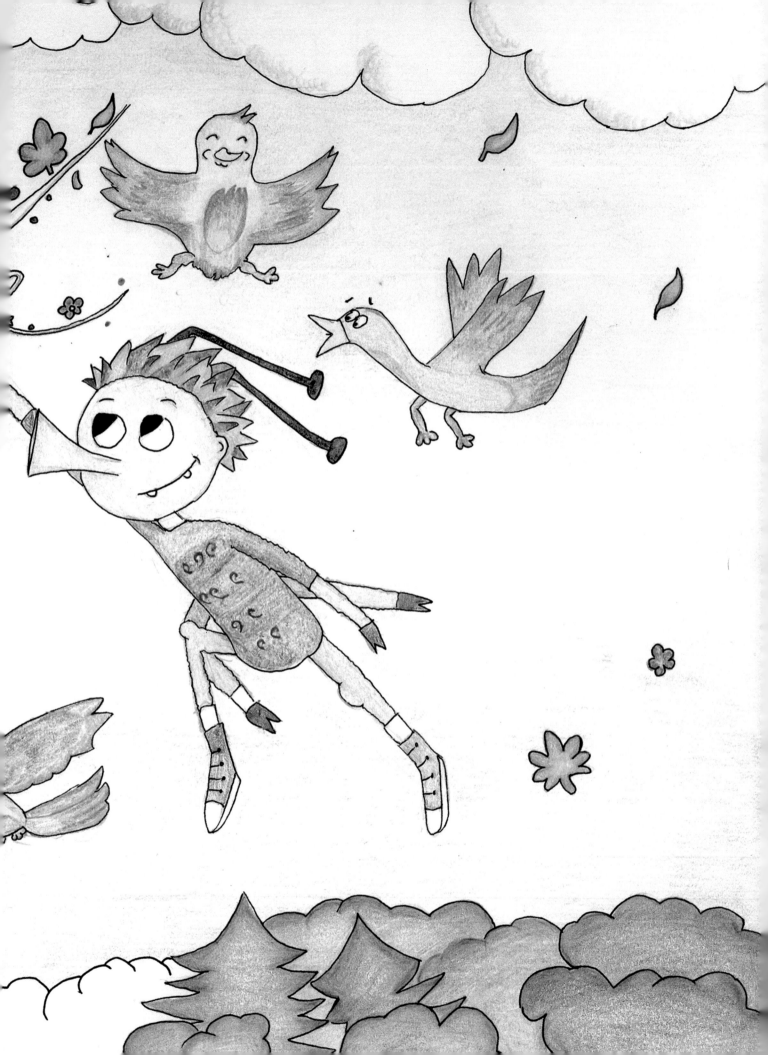

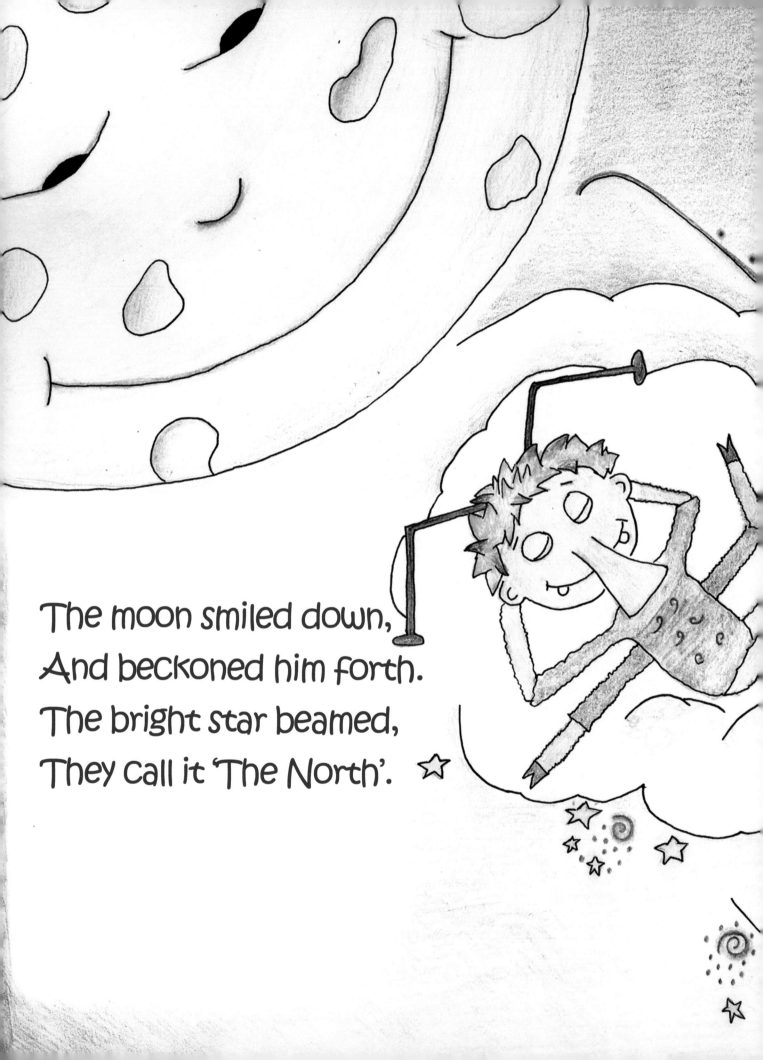

The moon smiled down,
And beckoned him forth.
The bright star beamed,
They call it 'The North'.

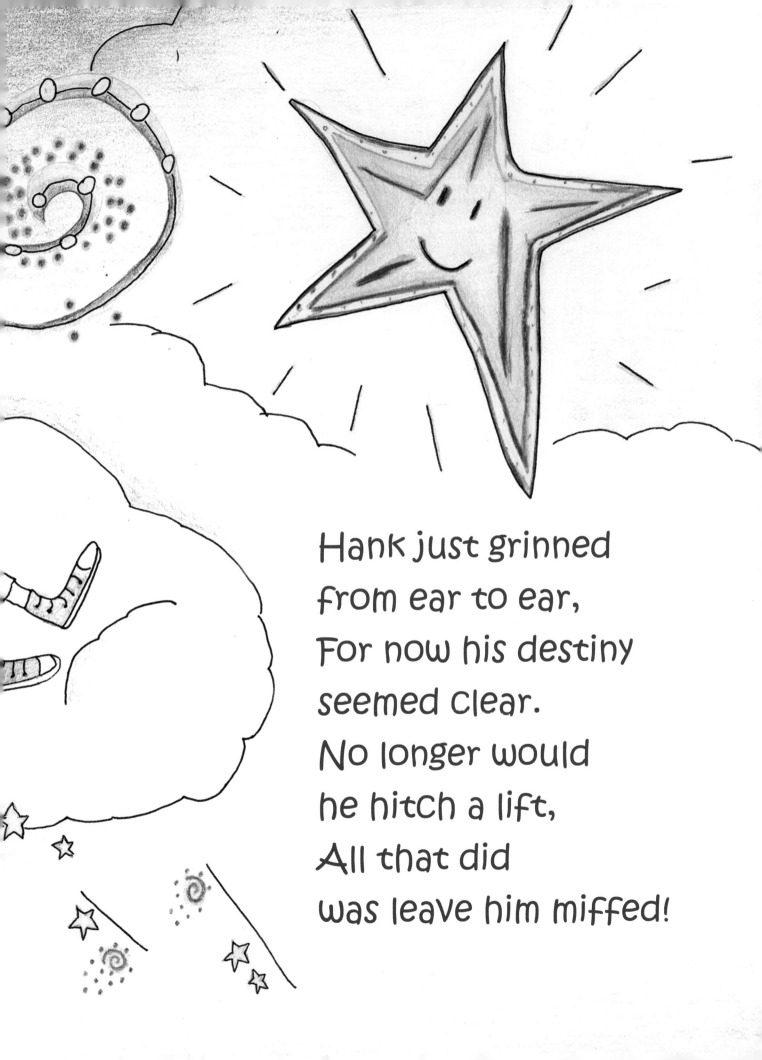

Hank just grinned
from ear to ear,
For now his destiny
seemed clear.
No longer would
he hitch a lift,
All that did
was leave him miffed!

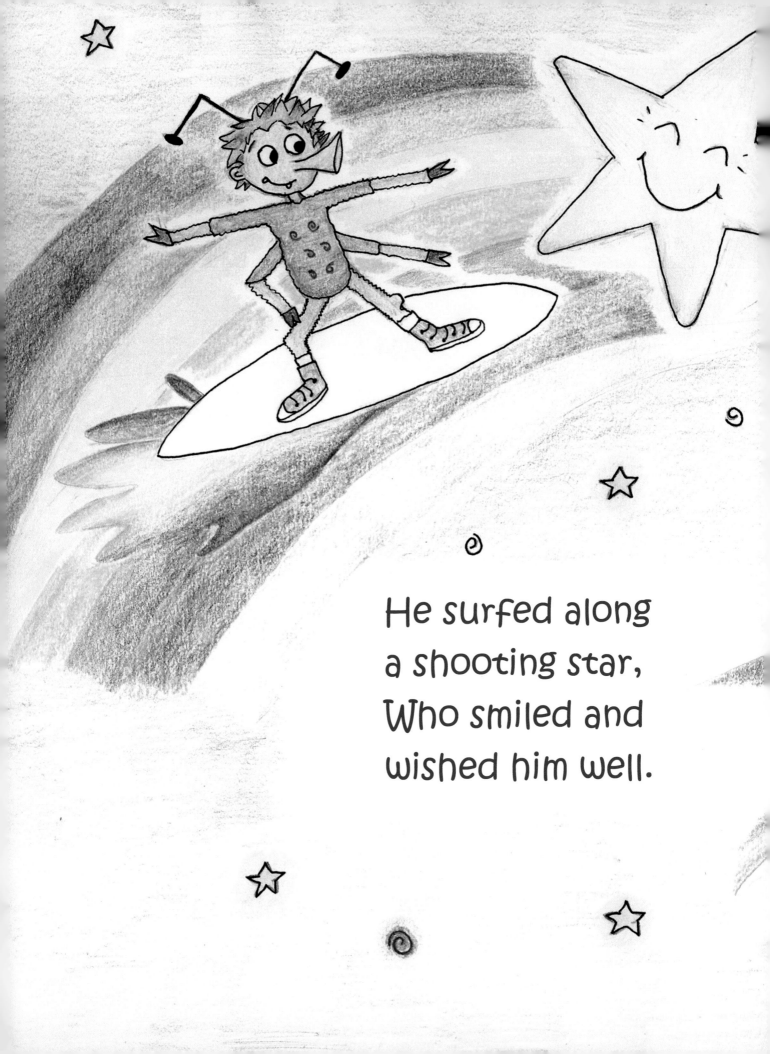

He surfed along
a shooting star,
Who smiled and
wished him well.

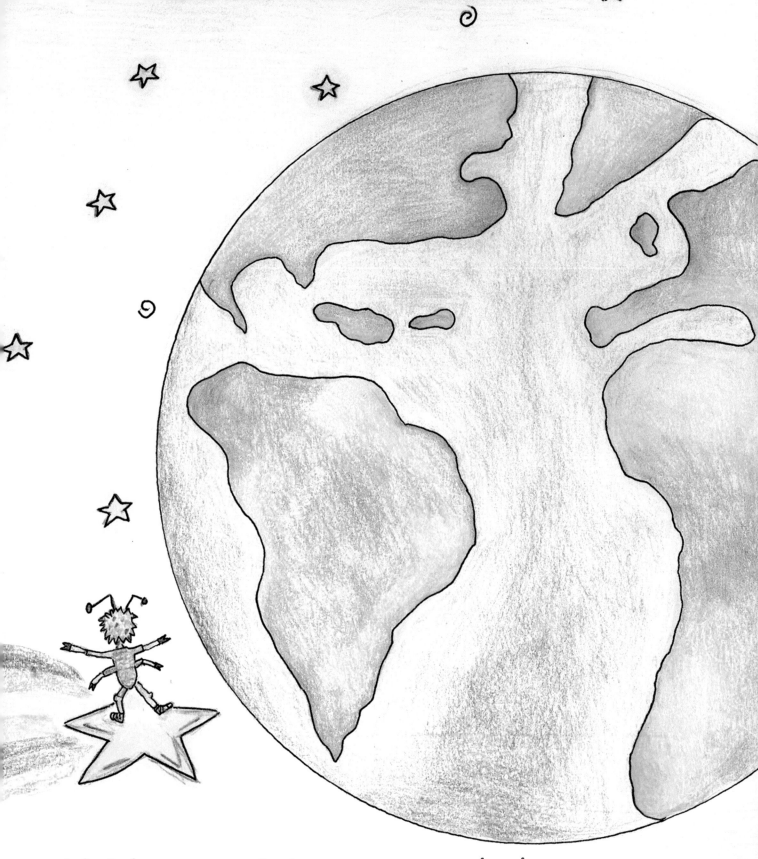

He'd never felt so grounded,
Then with the star he fell.

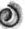

Back down to Earth,
A beautiful night,
And in his heart,
Hank kept the light.

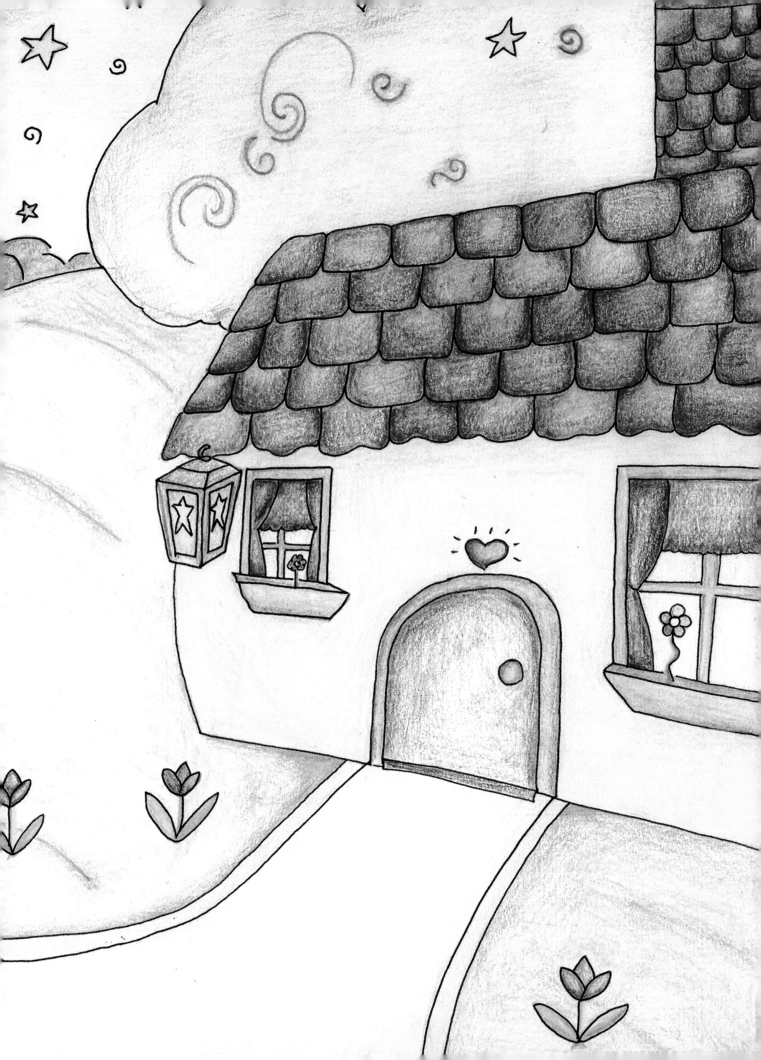

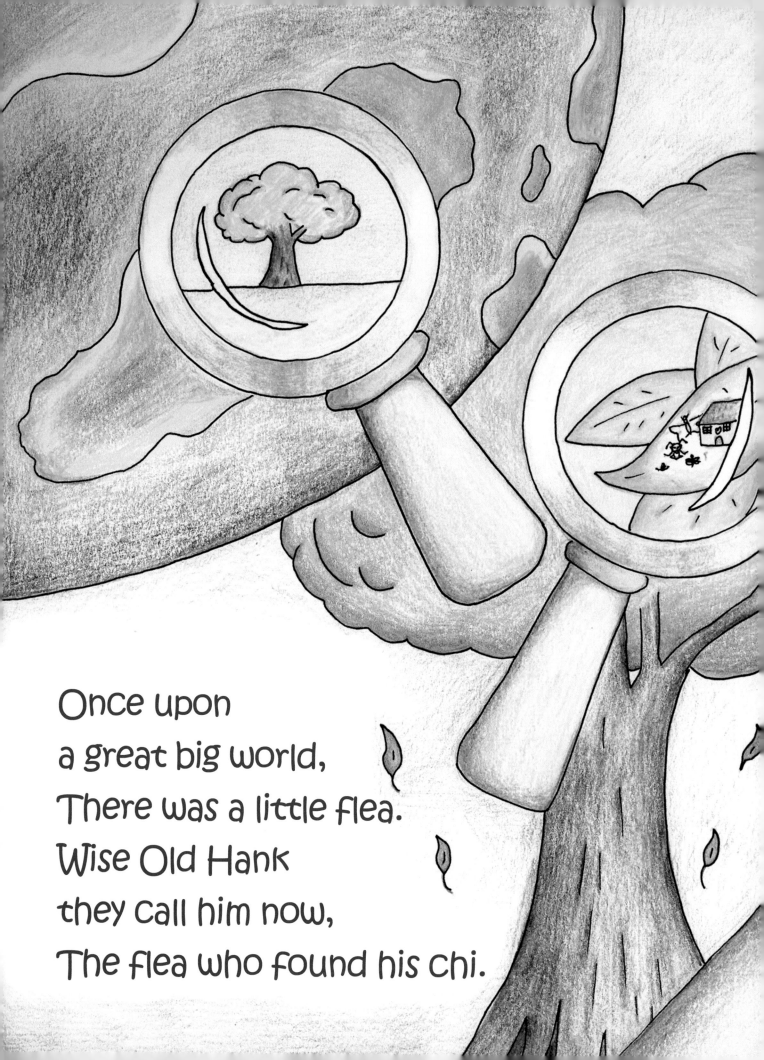

Once upon
a great big world,
There was a little flea.
Wise Old Hank
they call him now,
The flea who found his chi.

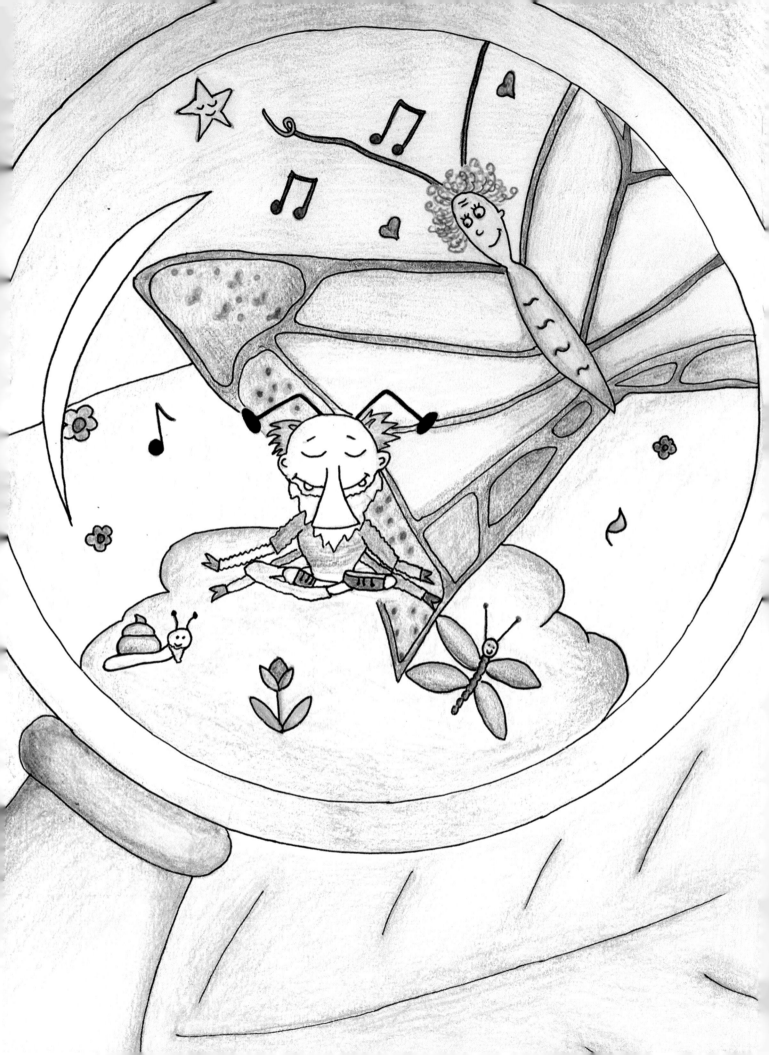

Hank's Tricky Words

Chums – buddies, friends, pals

Winced – dislike and look away from something yucky

Sucker – nose vacuum that fleas use to drink

Spangly – sparkly, beautiful, handsome

Hitched – travel without paying

Fulfilled – happy and satisfied

Jive – dance merrily

Beckoned – invite someone to come over to you

Miffed – annoyed and upset

Chi (" chee ") – The key to the magic and energy within you. Everybody and everything has chi inside.

Printed in the United States
By Bookmasters